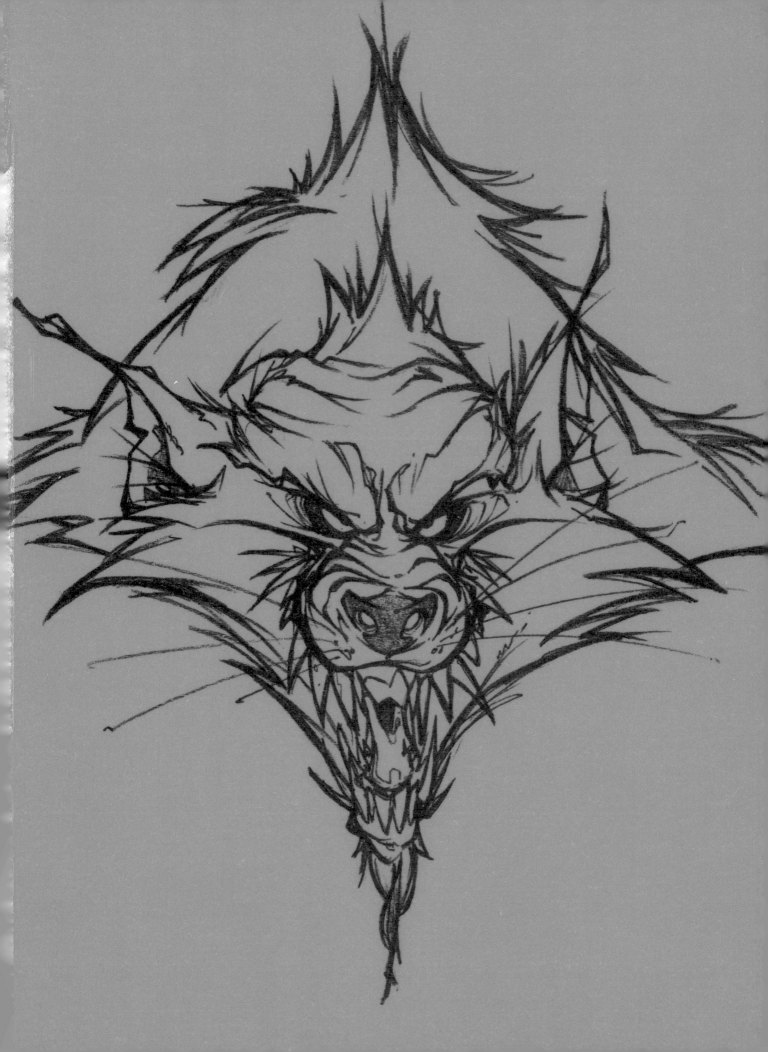

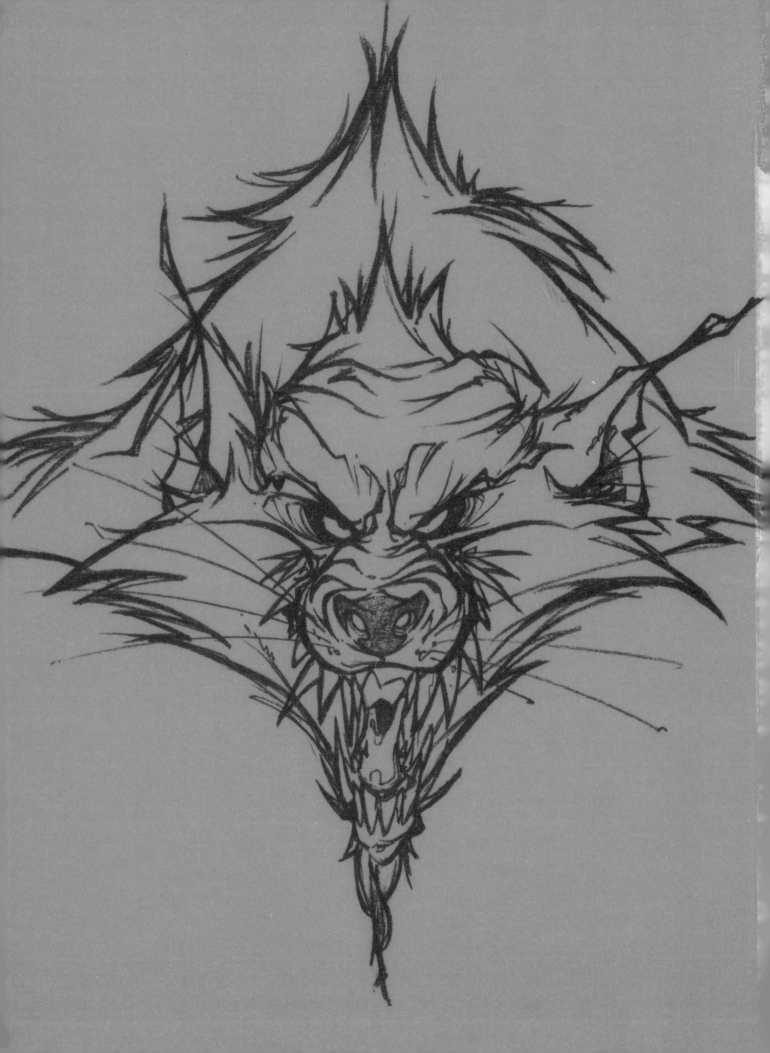

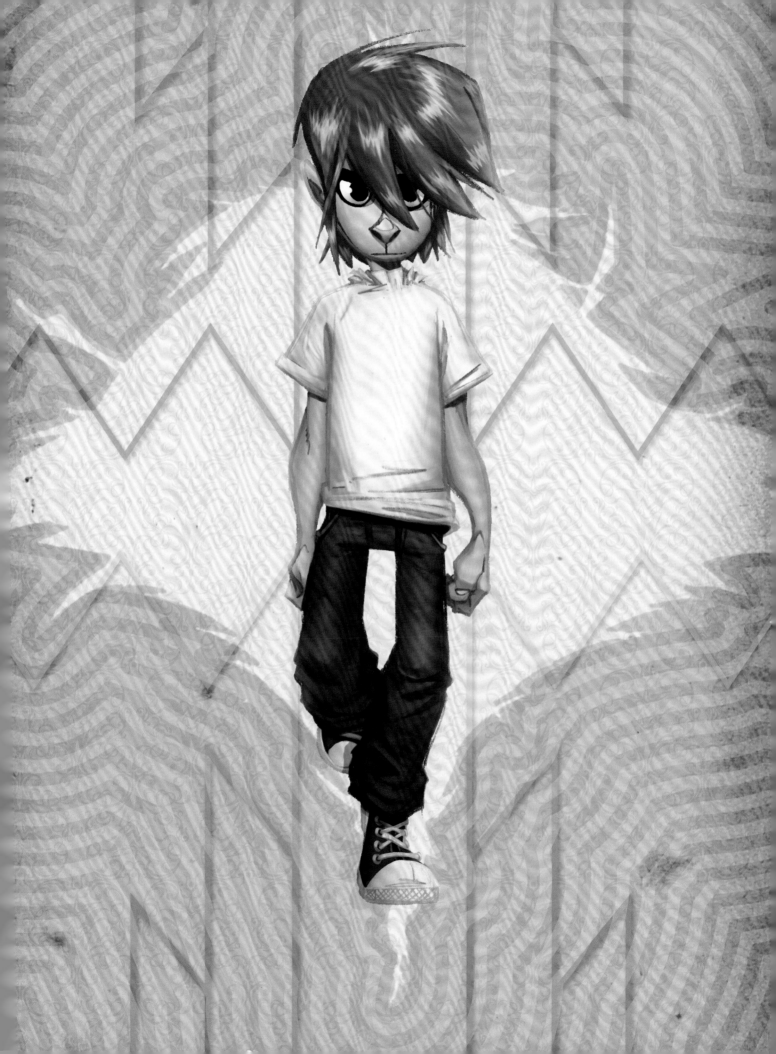

Bitten

THE FULL MOON BOOK

Expanding The Universe of
Cornelia Funke's Young Werewolf.

STORY
RAUL GARCIA

ART & DIRECTION
FRANCISCO HERRERA
herrerabox

COLOR
FERNANDA RIZO
whitefer

DESIGN
LEONARDO OLEA
oleatv

R&R COMMUNICATIONS INC.

THE ART OF HERRERA

OLEA creative

MAGNETIC PRESS
Mike Kennedy, *Publisher/President*
Wes Harris, *Vice President*
4910 N. Winthrop Ave #3
Chicago, IL 60640
www.magnetic-press.com

BITTEN "The Moon Book" Original Hardcover.
September 2015. FIRST PRINTING
Printed in China by Global PSD.

ISBN: 978-1-942367-01-7

INDEX

SPECIAL THANKS:

Parka Films
In Efecto
Alex Dilts
Antonio J Santamaria
Niklas K. Andersen
Rocio Ayuso
Karla Cervantes
Alex Herrera

FOREWORD

I have seen my stories in many costumes: on screens and on theatre stages, illustrated by many artists, retold in fifty countries and more than 35 languages. So why be excited about another adaptation, Cornelia?

Because with BITTEN everything is different. First of all – the book this project is based on, is a very short book. So in contrast to Inkheart or Thieflord, two books that had to be clipped and shrunken to become a movie, this story wasn't too long. We had to reinvent it to tell it in moving images.

Which was quite an adventure!

First of all : I always wanted to turn it into my love song for L.A. And when I teamed up with Raul and Francisco they both loved that idea. We all saw my boy hero Matt once he turned werewolf howl at the moon on the Hollywood Sign! We all felt Los Angeles had never been shown in an animated movie the way we see and love it. And where else would it be more believable to have a villain who not only played Werewolves in many movies but actually is one himself?

The passion and artistic skills Raul and Francisco brought to this is a gift to a storyteller that equals chests filled with treasure. No. In fact it is a much better gift!

So here is my book, Young Werewolf, seen through the eyes of a wonderful Spanish and an equally wonderful Mexican artist. I love they call it BITTEN!:)

Enjoy the treasures on these pages.

Cornelia Funke

PREFACE

Hollywood monster movies have always been a special treat for me. Along with my daily doses of Disney and Warner Brothers' cartoons, I have always been fascinated with the classic monsters from Universal and the people who inhabited them: Boris Karloff and his Frankenstein and the Mummy, Lugosi and his Dracula, or the immortal Lon Chaney Jr. and his Werewolf.

There was something very special about werewolves that always fascinated me. The full moon and its magic glowing light, the power of transformation, all the myths and lore about the mythical beasts...

When I read Cornelia Funke's "Young Werewolf," I knew I was in front of a very special treat. A diamond in the rough in the form of a children's book with a scope beyond the pages of the written word. The adventures of Matt were screaming to be adapted to something visual, big and exciting.

Cornelia had revived the old werewolf of yore with a new twist, funny, engaging and tapping the inner fears of growing up. I knew we had to make an animated film of the "Young Werewolf" and who could be better than Francisco Herrera to flesh out graphically the world of a young kid with furry issues?

Knowing the path was going to be tortuous and complicated, we teamed up to create a world where comedy and monsters will go hand to hand to create a love letter to Los Angeles and the magic of movies.

And what better way to start the creative ball rolling in the adventure of making the transition from page to screen than to stop for a moment in the world of the printed page again and create a lavish graphic novel, a visual trip to the world of Cornelia Funke's story about a little kid bitten by a mysterious creature.

And what a luxury to have as a travel companion the visual wizardly of Francisco Herrera, a true creative partner in a journey of discovery and wonder. Let's open the door to bigger things to come and enjoy every page of this sketchbook as we guide you through the creative process of searching for a world and the characters who inhabited it. Just like the old monster movies.

Raul Garcia
Los Angeles 2015.

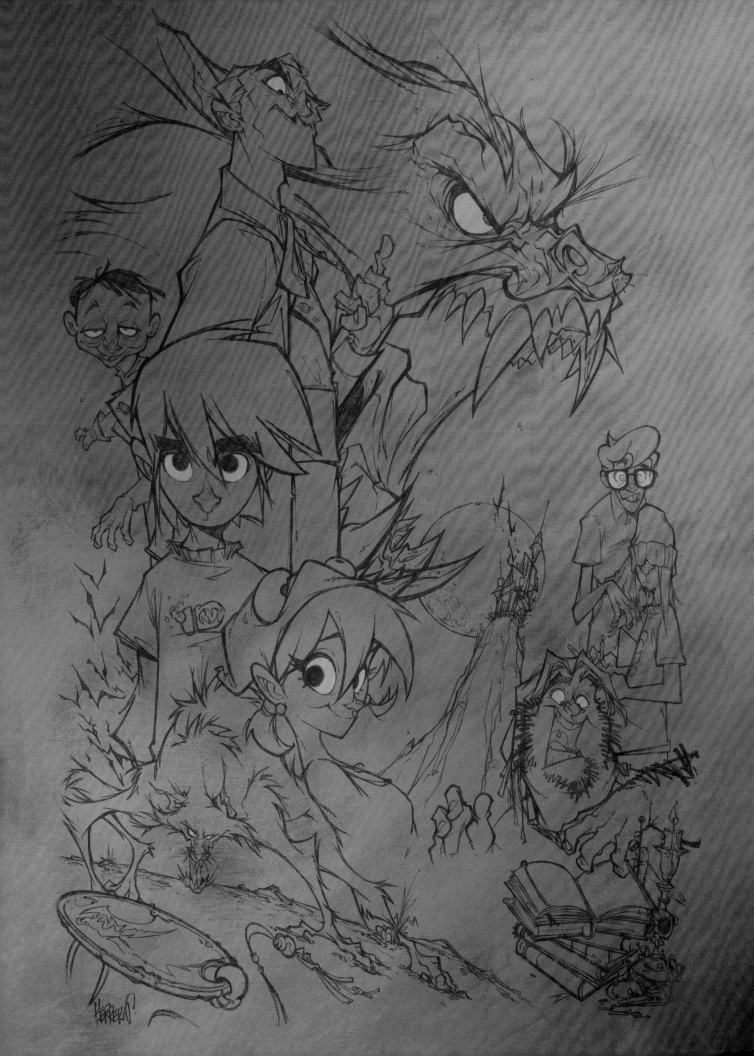

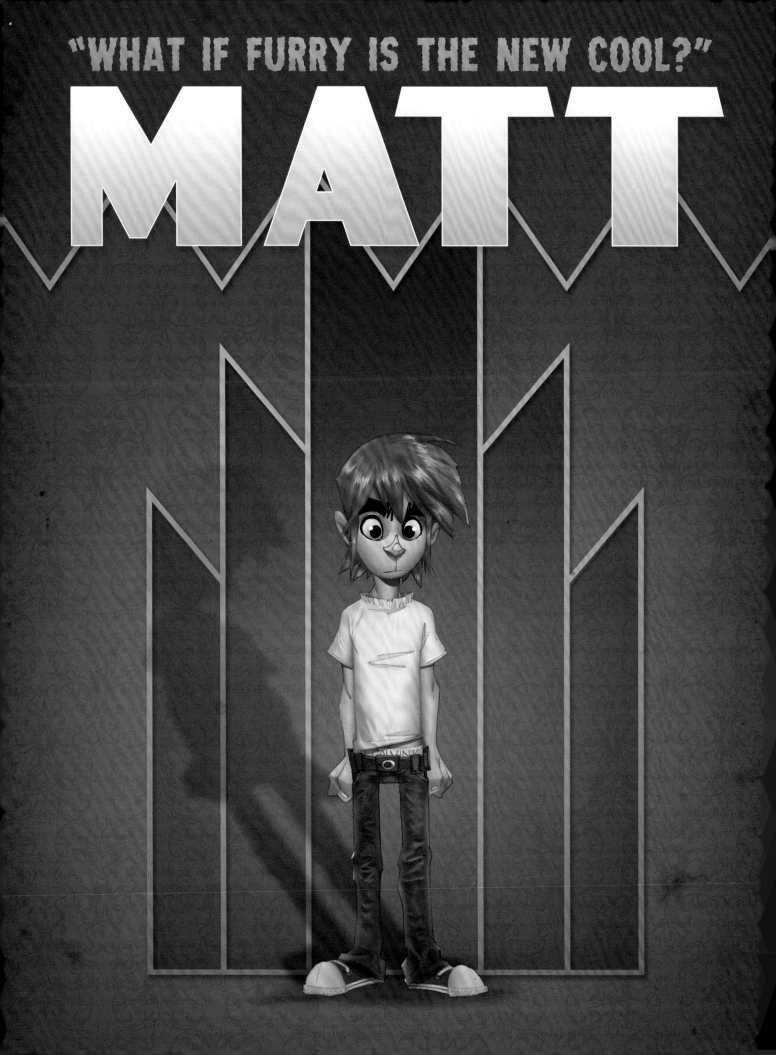

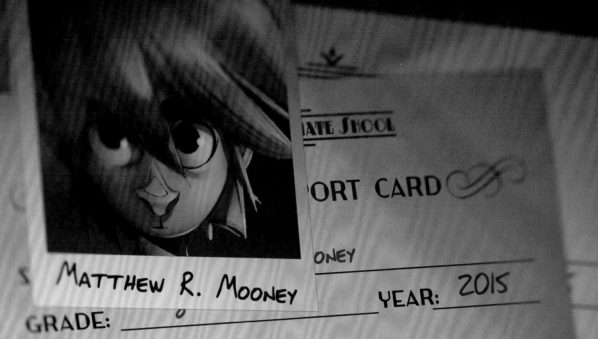

ATE SHOOL

ORT CARD

ONEY

Matthew R. Mooney YEAR: 2015

GRADE: _____

TEACHER'S MARK

SUBJECT	1	2	3	4	5	6	YR.
Speech and Drama	B	B	A	B+	B	B	B+
Physical Education	D	D	F	E	D	D	D+
Science	C	A	B+	B	A	A-	B+

RATINGS: A-SUPERIOR, B-GOOD, C-AVERAGE, D-UNSATISFACTORY, F-FAILURE

OBSERVATIONS:

Matthew Mooney shows a special interest in astronomy and science studies. He possesses a vivid imagination, which is sometimes mistaken as a lack of interest in class. Matthew is a quiet, earnest and hardworking student. Areas for improvement include greater interest and participation in team sports activities. His physical education marks could be greatly improved with proper motivation.

JOHN S. PHILLIPS PRINCIPAL, INSTRUCTOR

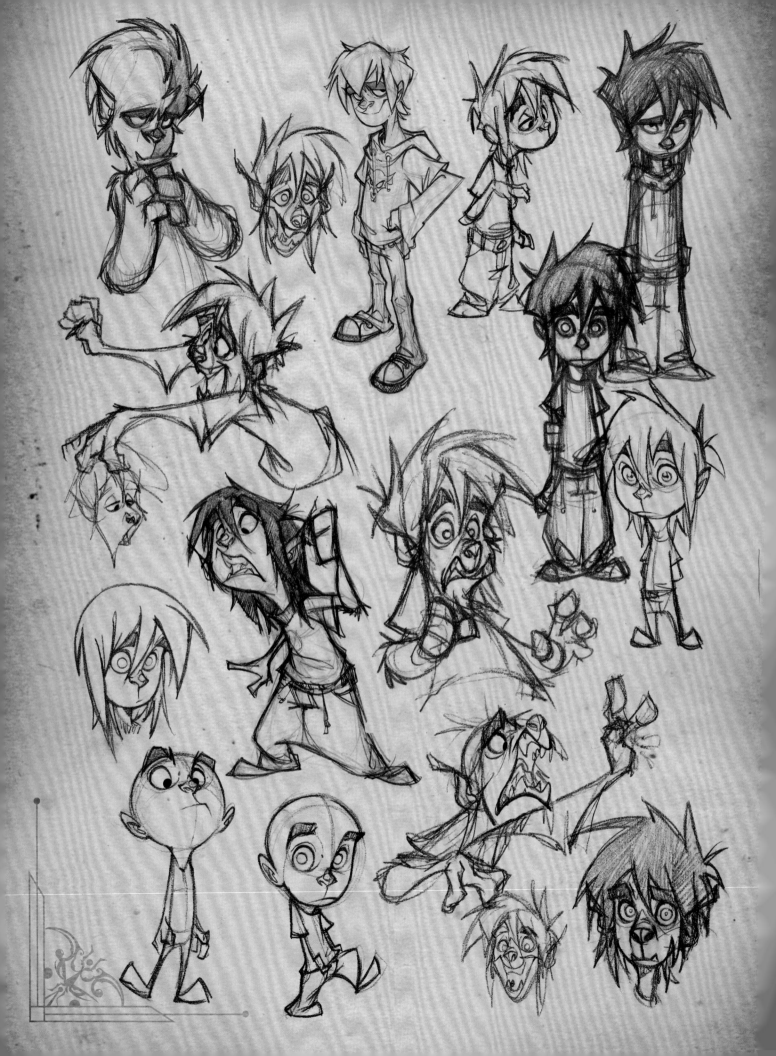

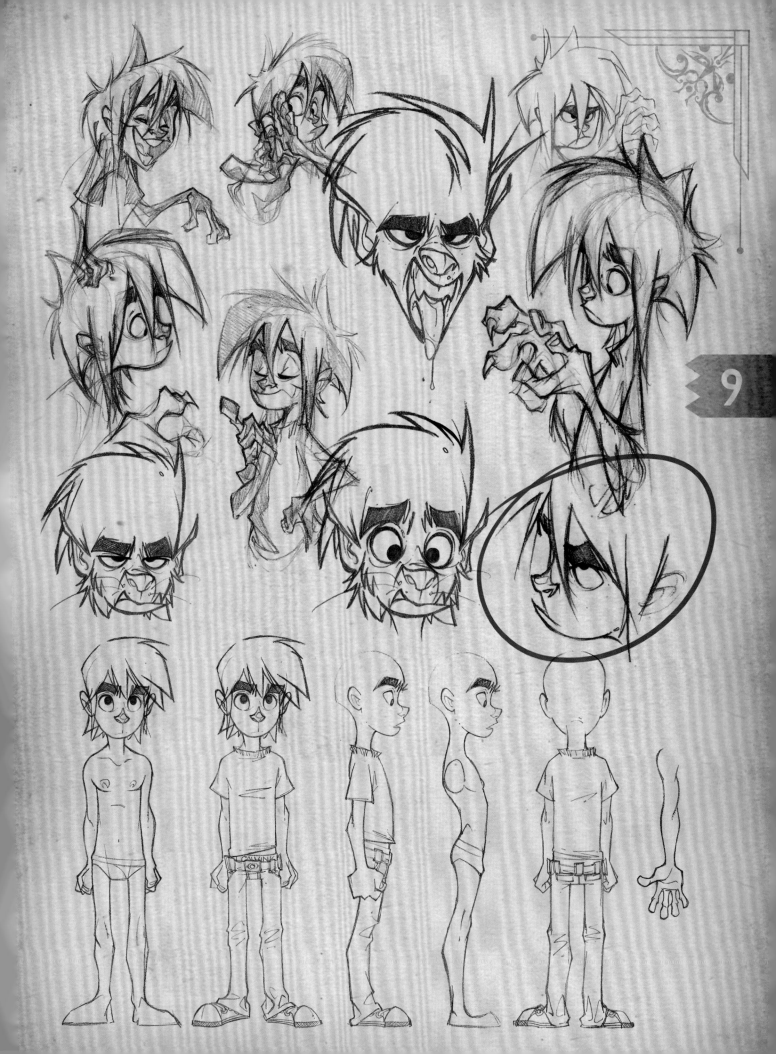

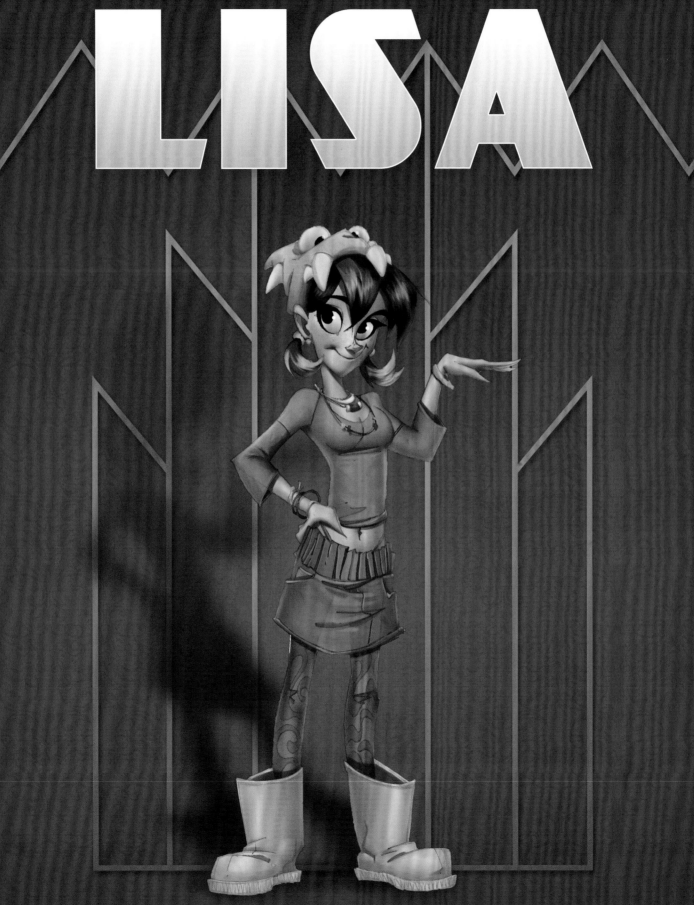

●●●○○ FUNKE 🛜 4:21 PM LISA'S PHONE 65% 🔋

Sun, July 9, 12:18 AM

MY BEST FRIEND HAS BEEN BITTEN BY A WEREWOLF. CAN U HELP?...

WT... YEAH! RIGHT!

THIS IS FOR REAL!

HA-HA, SURE.

Delivered

OMG! NO WAY!

SEND

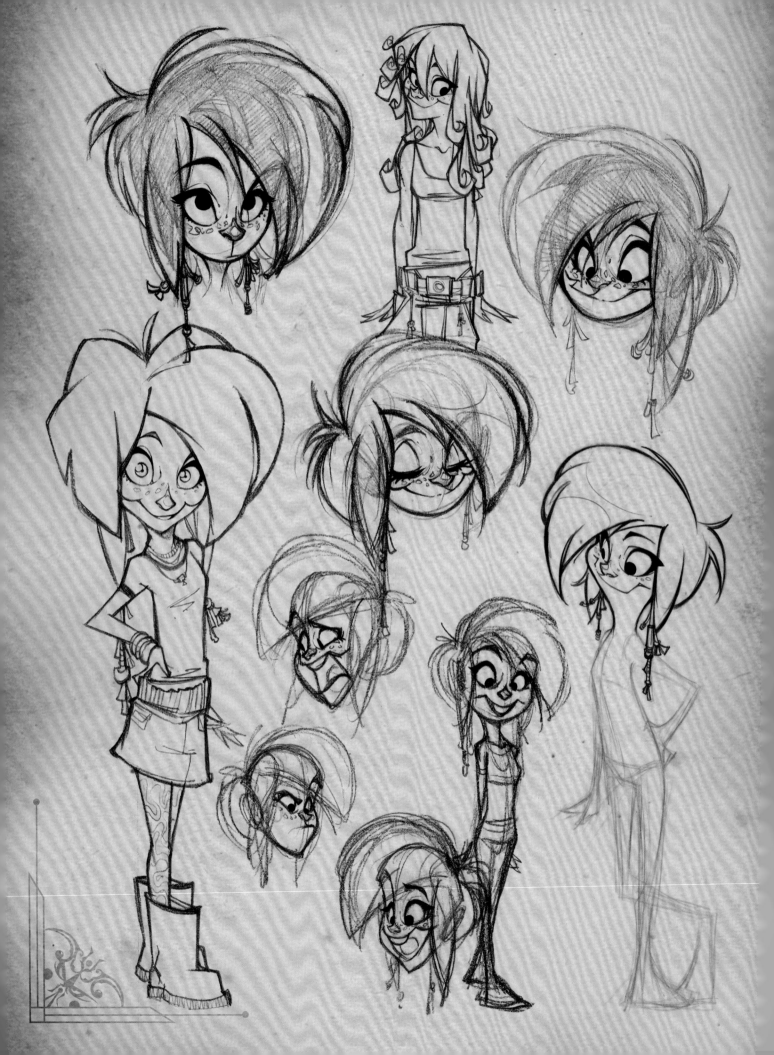

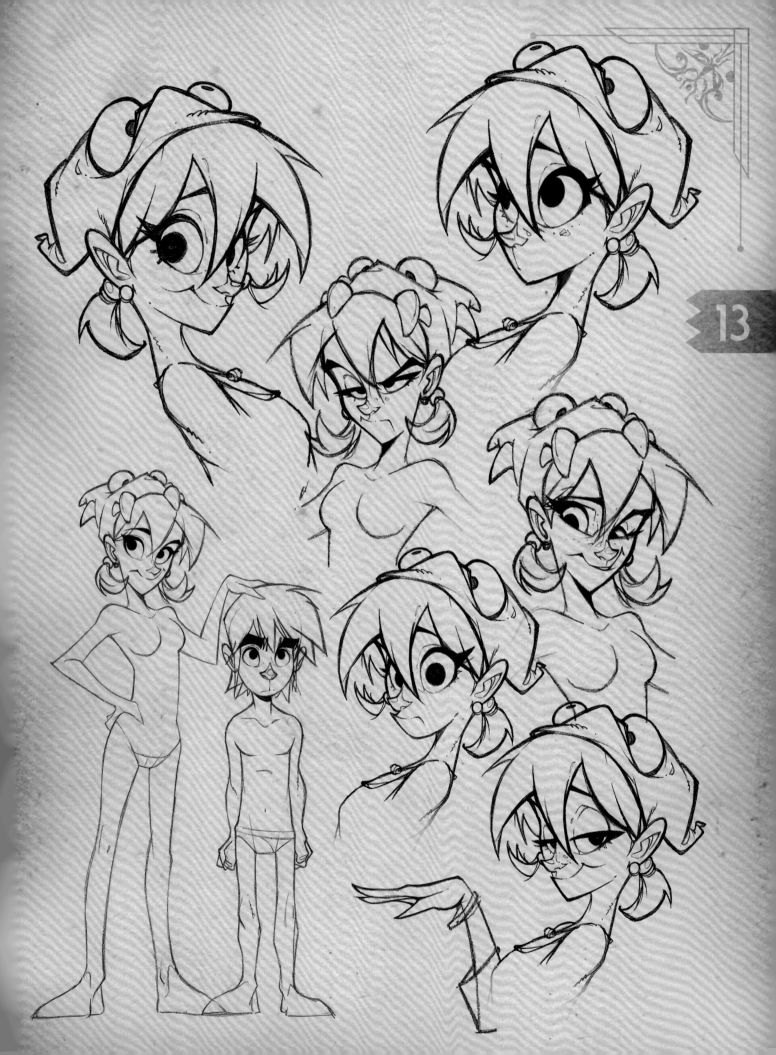

"I'M ALWAYS READY TO SINK
MY TEETH INTO A JUICY ROLL."

FOWLSWEATHER

"FILMS DO CHANGE IN THE WAY THEY ARE PERCEIVED."

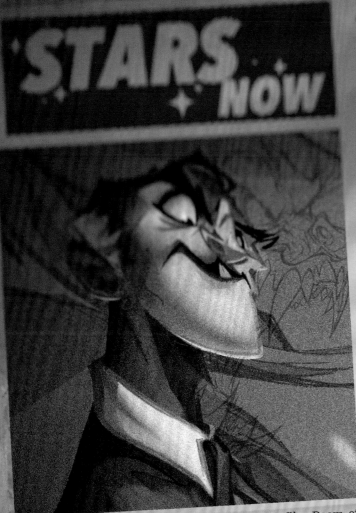

WE'RE TALKING WOLVES!

"YOU ONLY HAVE ONE CHANCE TO MAKE AN IMPRESSION AND SINK YOUR TEETH INTO IT."

Archibald Ernst Fowlsweather's latest film Doom of the Werewolf displays his tongue-in-cheek characterization as the quintessential werewolf incarnation. It is but the latest installment of a series of films that's given Fowlsweather the well-deserved moniker of "King of the B Movies". Here, Fowlsweather stars as the meek Allister Brown, a turn of the century school teacher, with a secret involving bloody encounters in dark alleys on nights when the moon is full. As a werewolf, Fowlsweather has tackled the character from film to film varying widely in appearance and personality with each version taking a vaguely sardonic approach to the subject. In Doom of the Werewolf, Fowlsweather has outdone himself.

Gaudy, violent, elegant and witty, the legendary actor seems to have found the secret the eternal youth. We had the pleasure of talking with him a few weeks prior to the opening of his latest film in the comfort of his home in Los Angeles.

STARS NOW: Let's start at the beginning of your career... Why werewolves? Why horror films? What made you choose those kinds of roles?

AE FOWLSWEATHER: An actor is an actor and you have to see the, let's say "juice", in the roles you are offered. Once you have found a role that suits you, you only have one chance to make an impression and sink your teeth into it.

STARS: So... Do you have any special affinity for lycanthropy?

FOWLSWEATHER: I was lucky to be in the right place at the right time. After I played the character a couple of times though, I was worried that I might become too close to him and begin to recognize him in myself. A very proper anxiety, of course. But you have to understand, I am not really a character in this role. It is a curse upon me. I am to be pitied, no condemned, as I am a werewolf now because I must be one.

STARS: But you've been widely recognized as a true master of horror - the werewolf who set the standard against which all others are measured.

FOWLSWEATHER: I have one thing that I would like to say. In the last year, I was given by the Los Angeles Film Critics Association a career achievement award. I really didn't think that I deserved it on the basis of my films, and I was wondering if they did. You know, because films do change in the way they are perceived. There are films that become classics that weren't classics when they were made, and I just wonder if this award was given to me because of my long career in films or just because I am the last actor of my kind.

STARS: Do you believe in werewolves? Vampires? The supernatural world?

FOWLSWEATHER: They're all nothing but movie clichés.

STARS: What about holy water, silver bullets - the various paraphernalia used to kill vampires and werewolves?

FOWLSWEATHER: Silver bullets are the first thing you have to rule out. They are just another movie cliché. Nothing can kill a werewolf except another werewolf. ✦

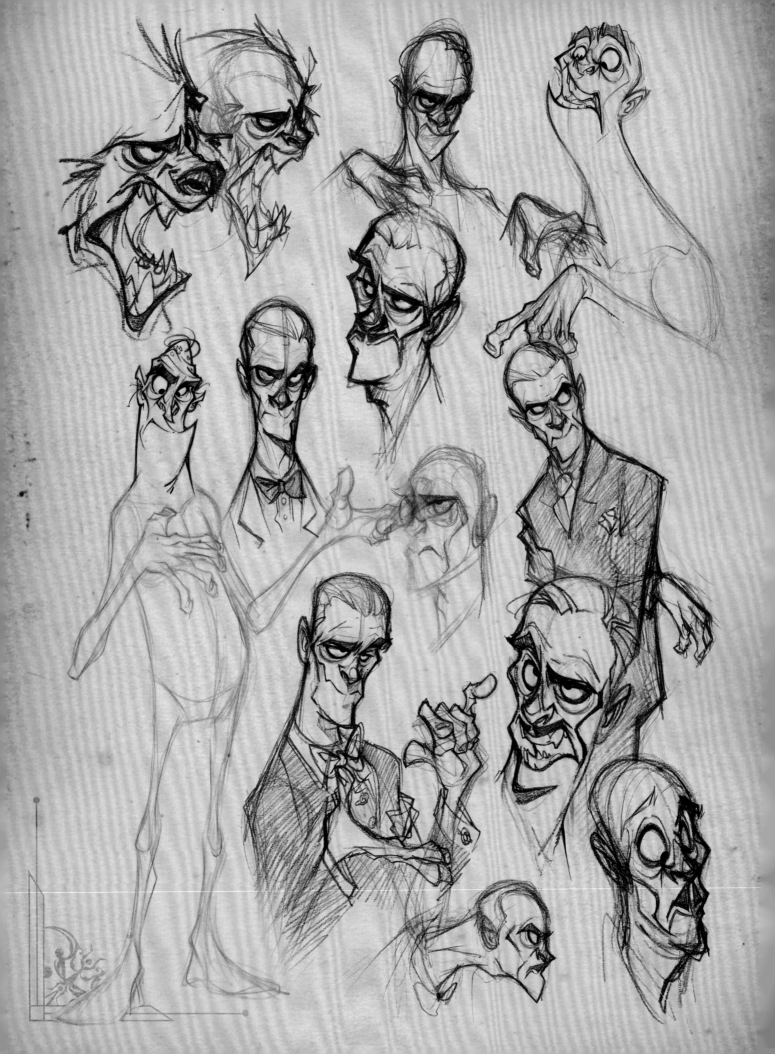

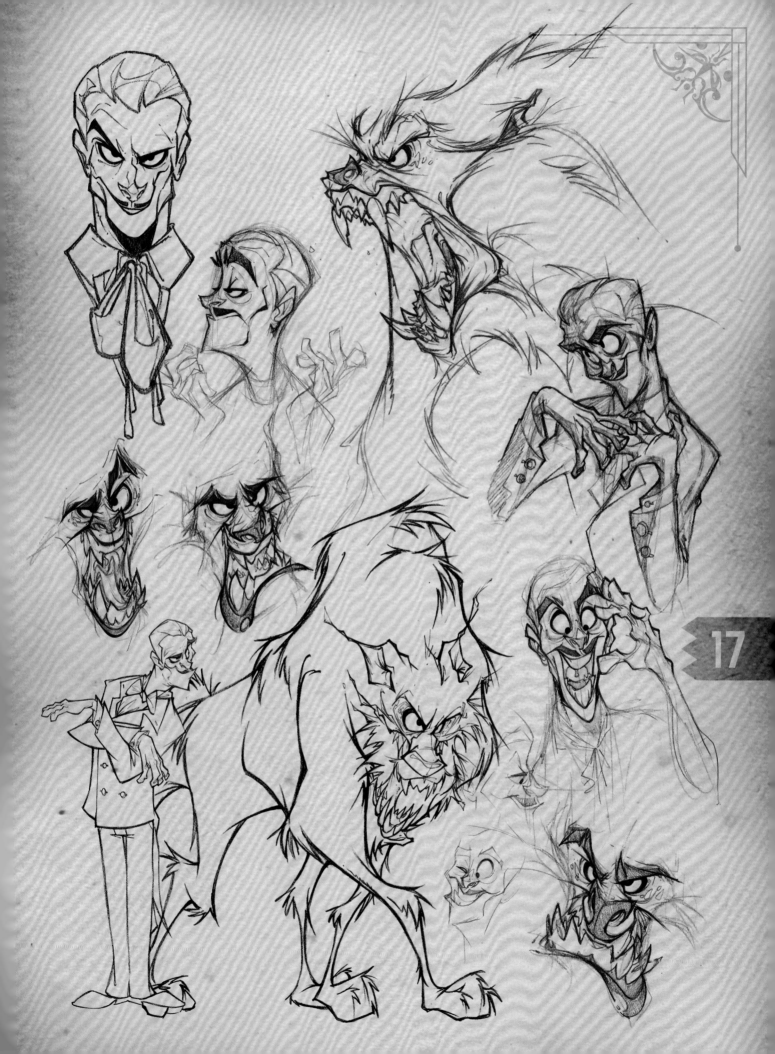

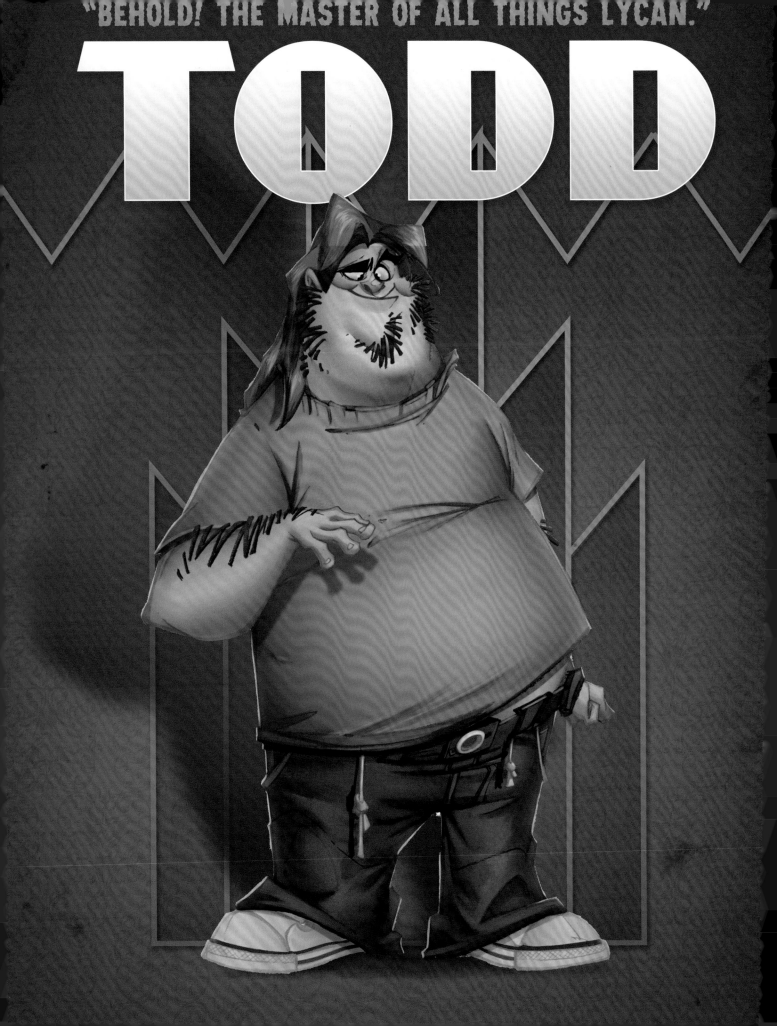

LYCAN

ATTRIBUTES.- Werewolf hunters are analytical and educated. Well versed in animal anatomy and basic medical skills. Werewolf Hunters are excellent shooters and skillful weaponsmiths able to craft guns, daggers, silver bullets and small blades.

PHYSICAL.- 5
SOCIAL.- 8
MENTAL.- 7
ABILITIES.- Weaponsmith. Alchemy. Chemistry.
TALENTS.- Crafts. Analytical thought. Forging amulets.
RESEARCH.- Library of Magic Spells and Ancient Curses-
350 volumes
RANK.- Senior Master Hunter

MONSTERS & HUNTERS

LUCY CARDS

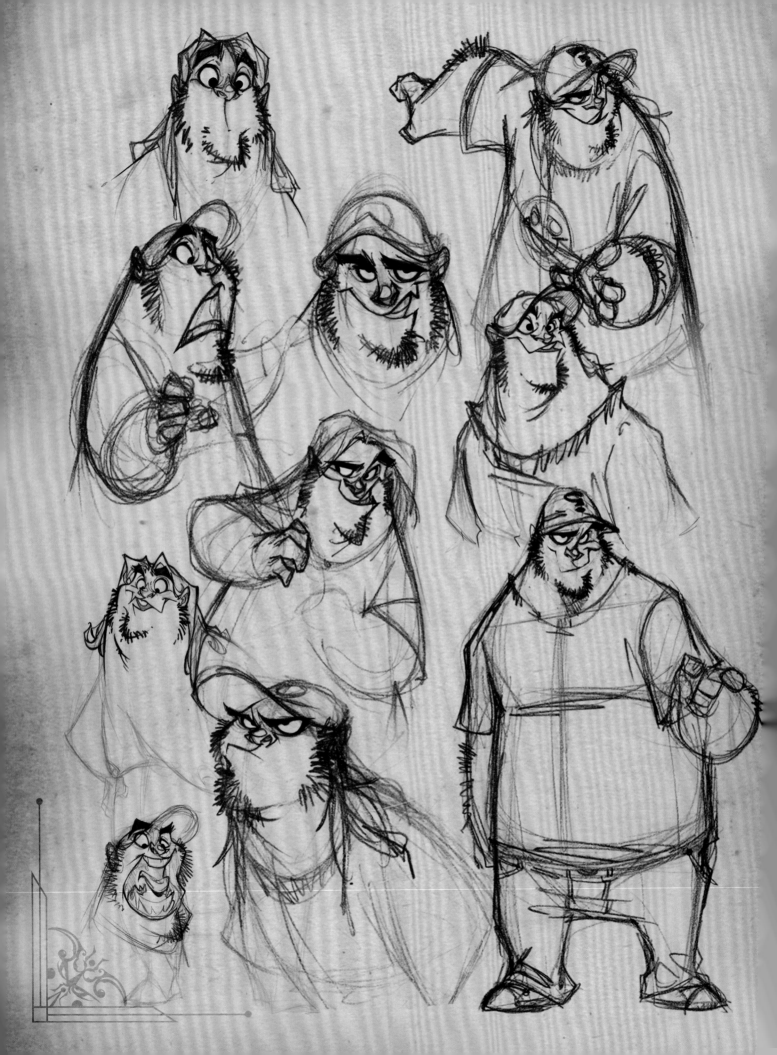

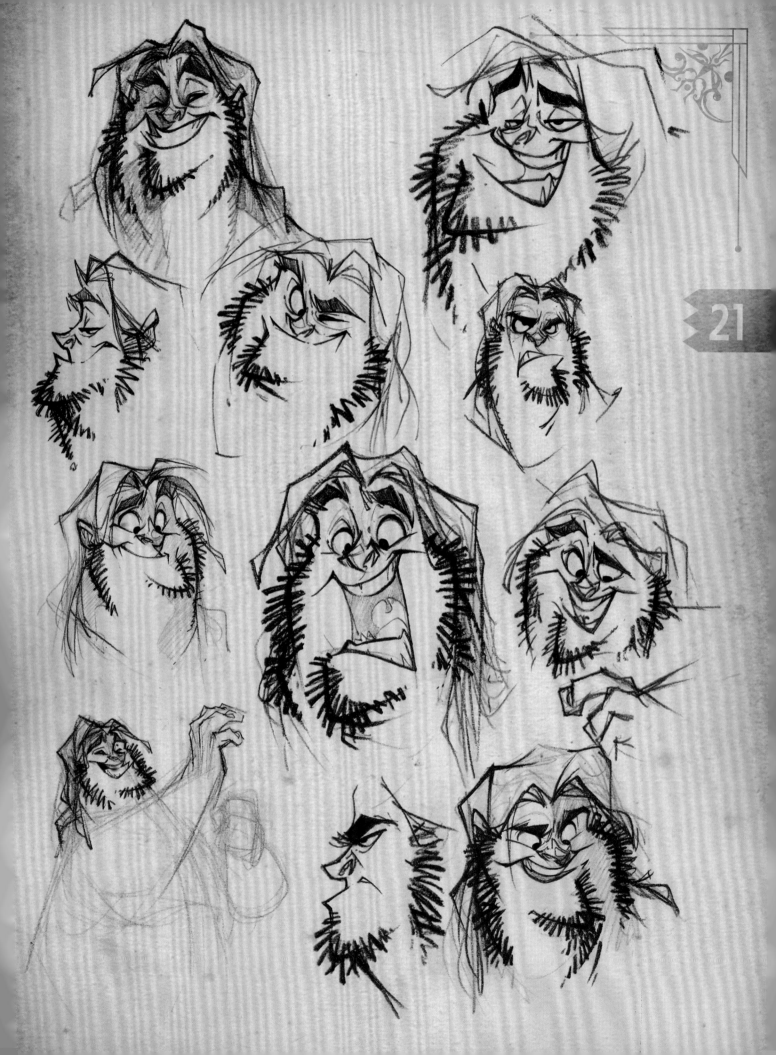

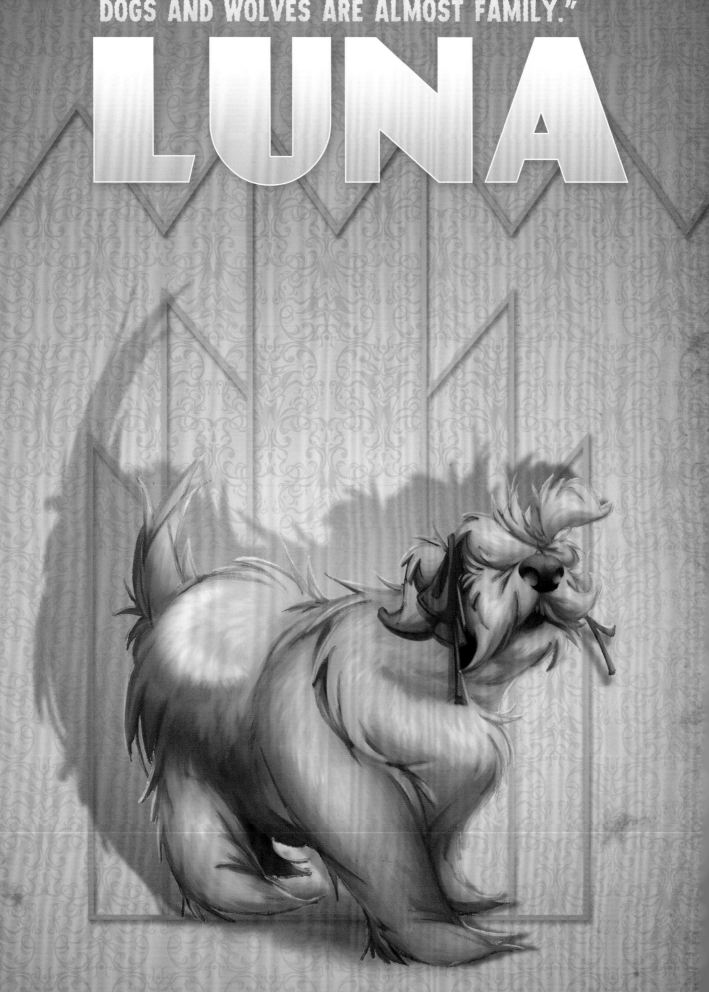

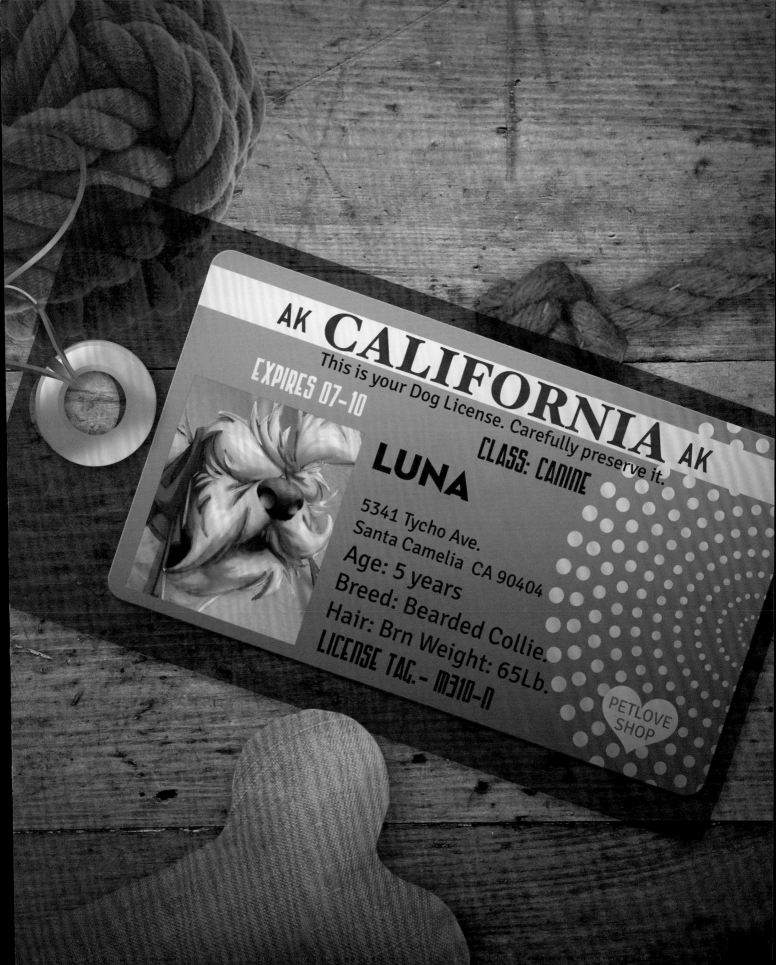

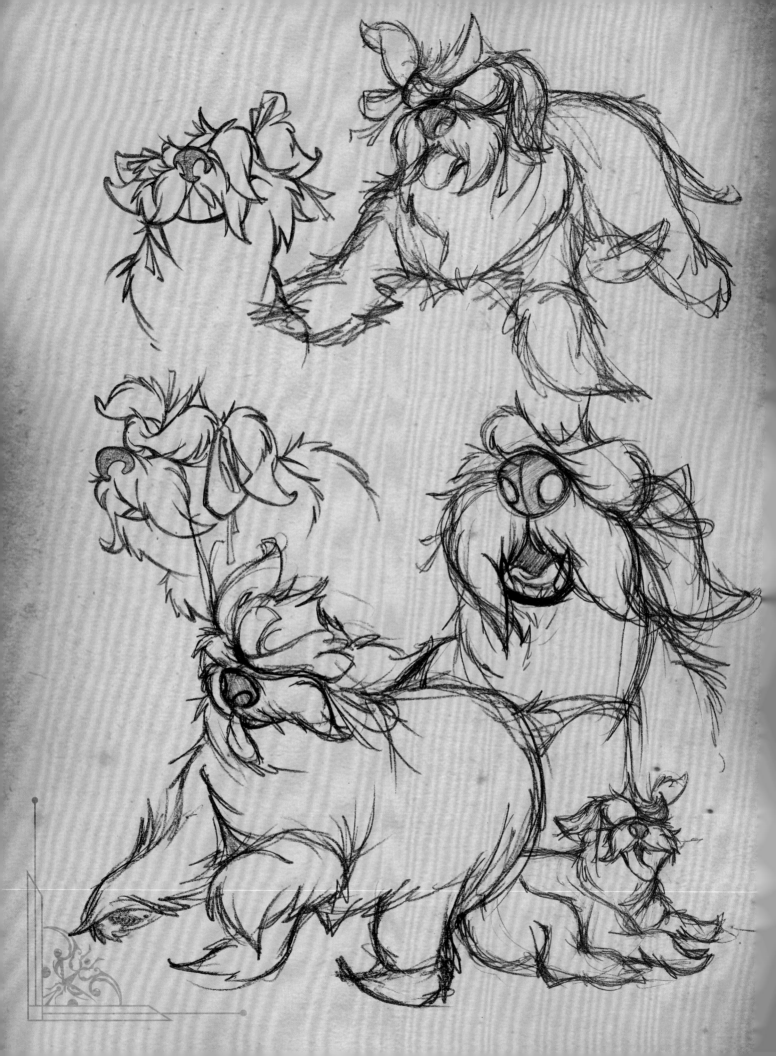

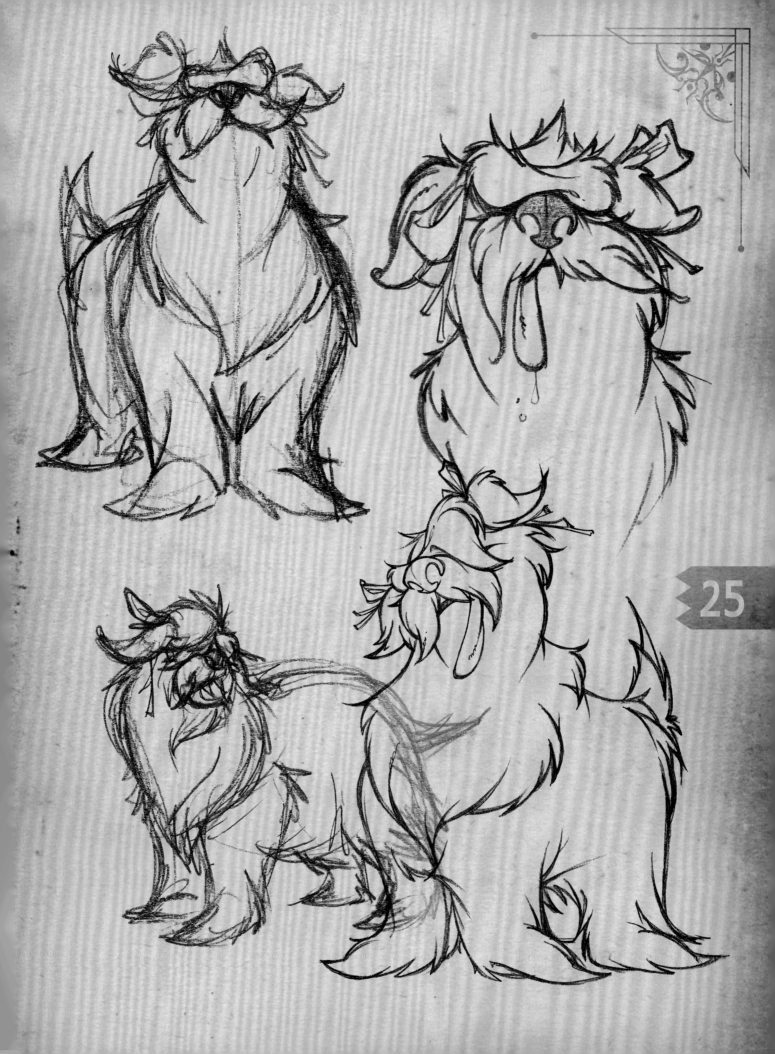

CROONIES

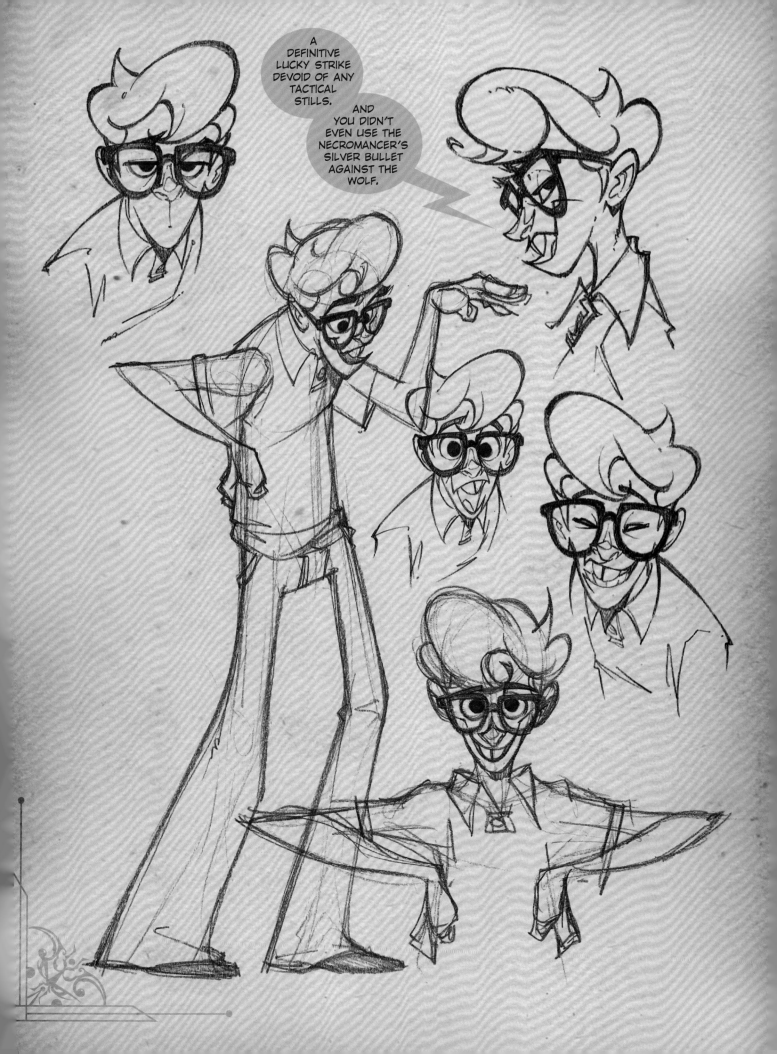

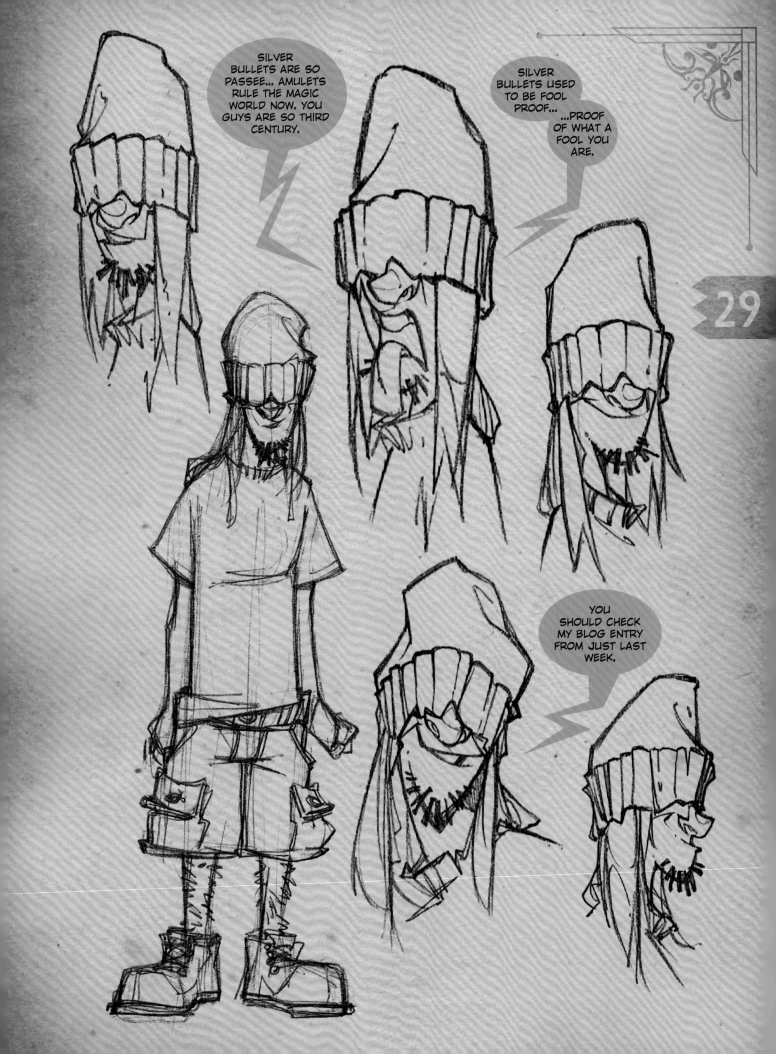

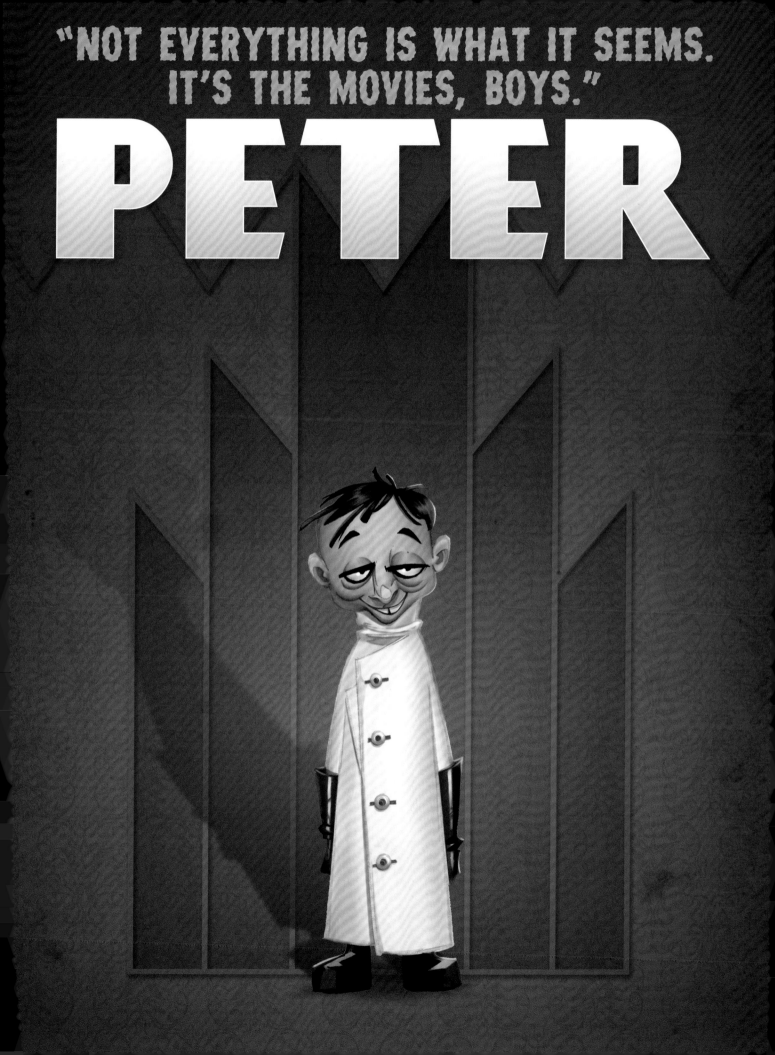

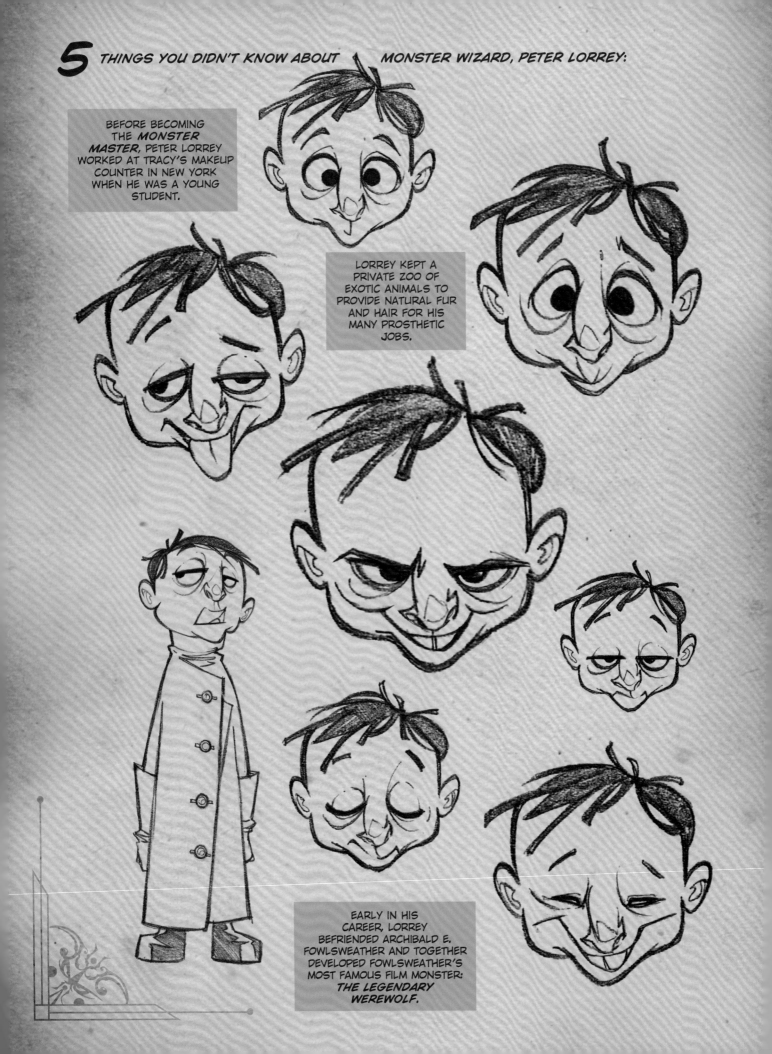

5 THINGS YOU DIDN'T KNOW ABOUT MONSTER WIZARD, PETER LORREY:

BEFORE BECOMING THE *MONSTER MASTER*, PETER LORREY WORKED AT TRACY'S MAKEUP COUNTER IN NEW YORK WHEN HE WAS A YOUNG STUDENT.

LORREY KEPT A PRIVATE ZOO OF EXOTIC ANIMALS TO PROVIDE NATURAL FUR AND HAIR FOR HIS MANY PROSTHETIC JOBS.

EARLY IN HIS CAREER, LORREY BEFRIENDED ARCHIBALD E. FOWLSWEATHER AND TOGETHER DEVELOPED FOWLSWEATHER'S MOST FAMOUS FILM MONSTER: *THE LEGENDARY WEREWOLF.*

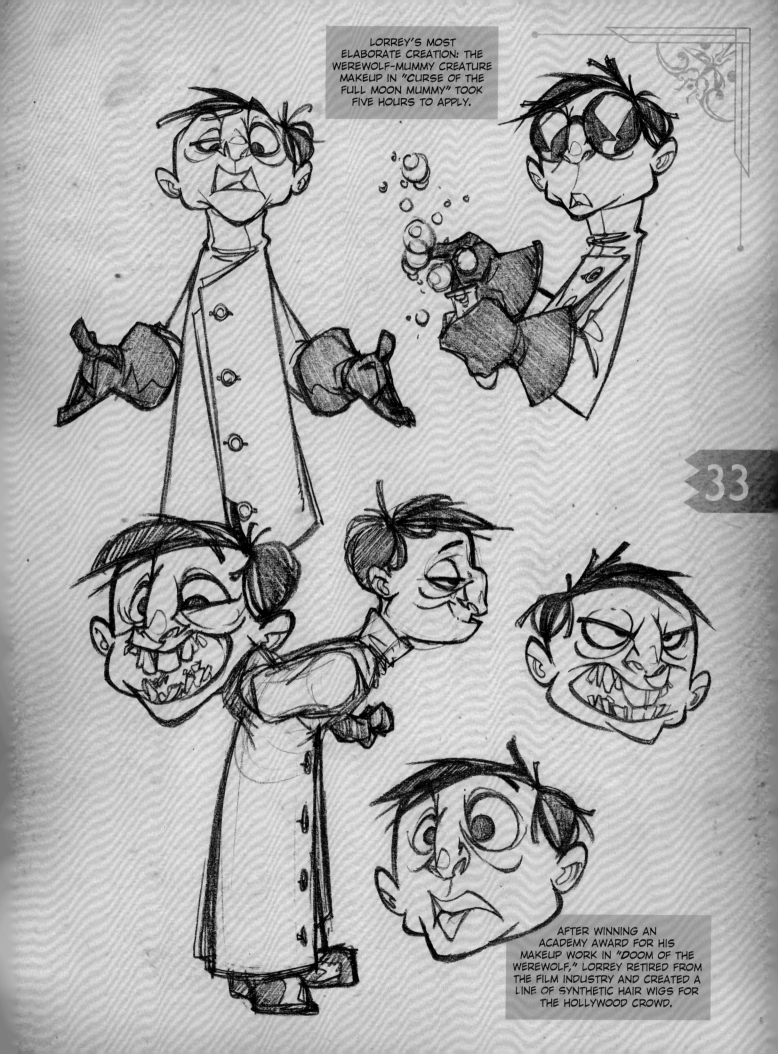

33

THE B[ff]

PETER FOWLSWEATHER LISA MATT LUNA

FULL CAST

TODD CROONIES

MOON WALK

NEW

CRESCENT

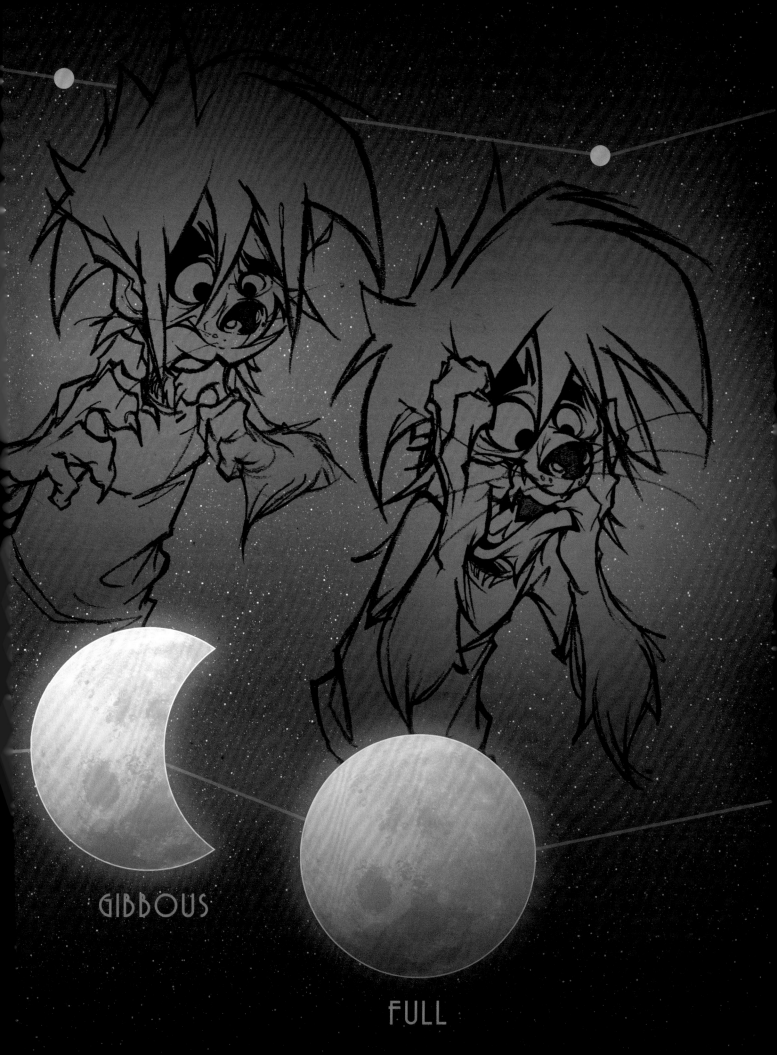

GIBBOUS

FULL

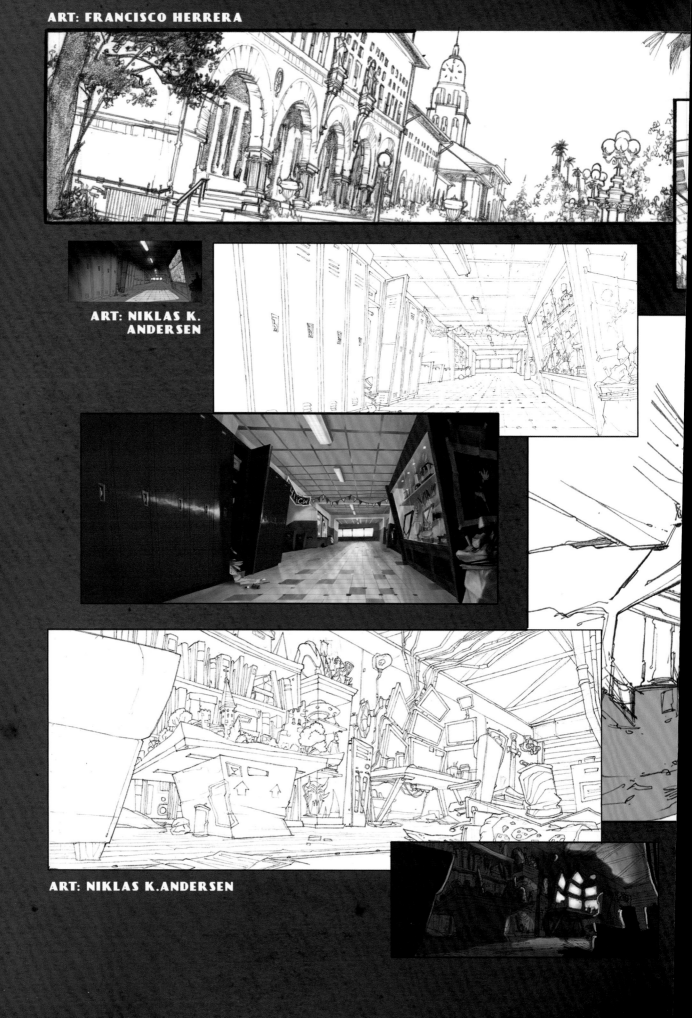

ART: FRANCISCO HERRERA

ART: NIKLAS K. ANDERSEN

ART: NIKLAS K.ANDERSEN

ENVIRONMENTS

ART: FRANCISCO HERRERA

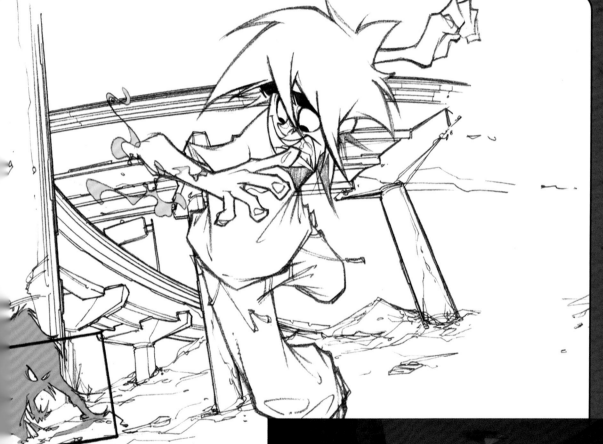

ART: FRANCISCO HERRERA

ART: NIKLAS K.ANDERSEN

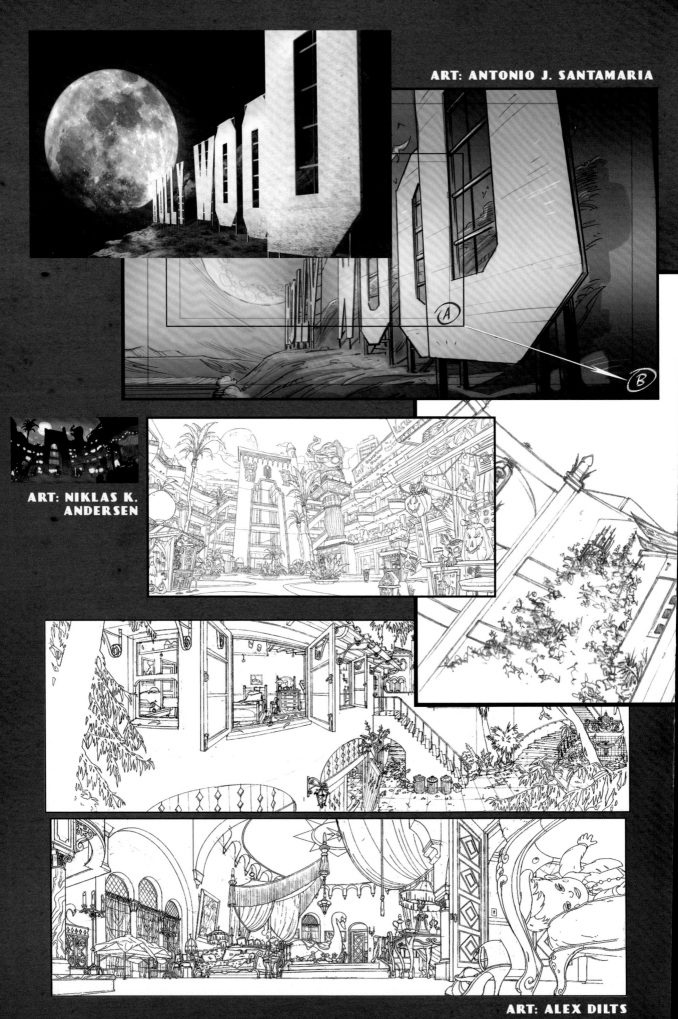

ART: ANTONIO J. SANTAMARIA

ART: NIKLAS K. ANDERSEN

ART: ALEX DILTS

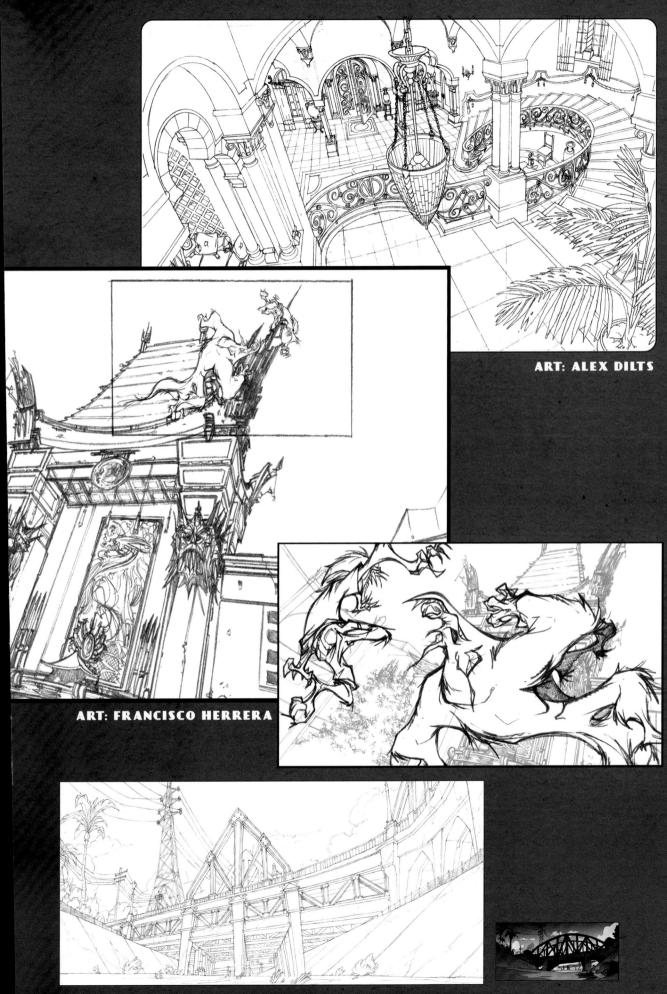

ART: ALEX DILTS

ART: FRANCISCO HERRERA

ART: NIKLAS K. ANDERSEN

Bitten

GRAPHIC NOVEL SNEAK PEEK

Matt, a shy 12 year old boy, is bitten by a strange creature. Soon he finds out he's been bitten by a werewolf. Now he needs to find an antidote before the next full moon or he will become a werewolf forever. His best friend, Lisa, and Todd, a presumed professional werewolf hunter, will help him in his quest.

But what if it's so much fun to be a wolf?
And - No fun at all- the first werewolf
is still hunting you?

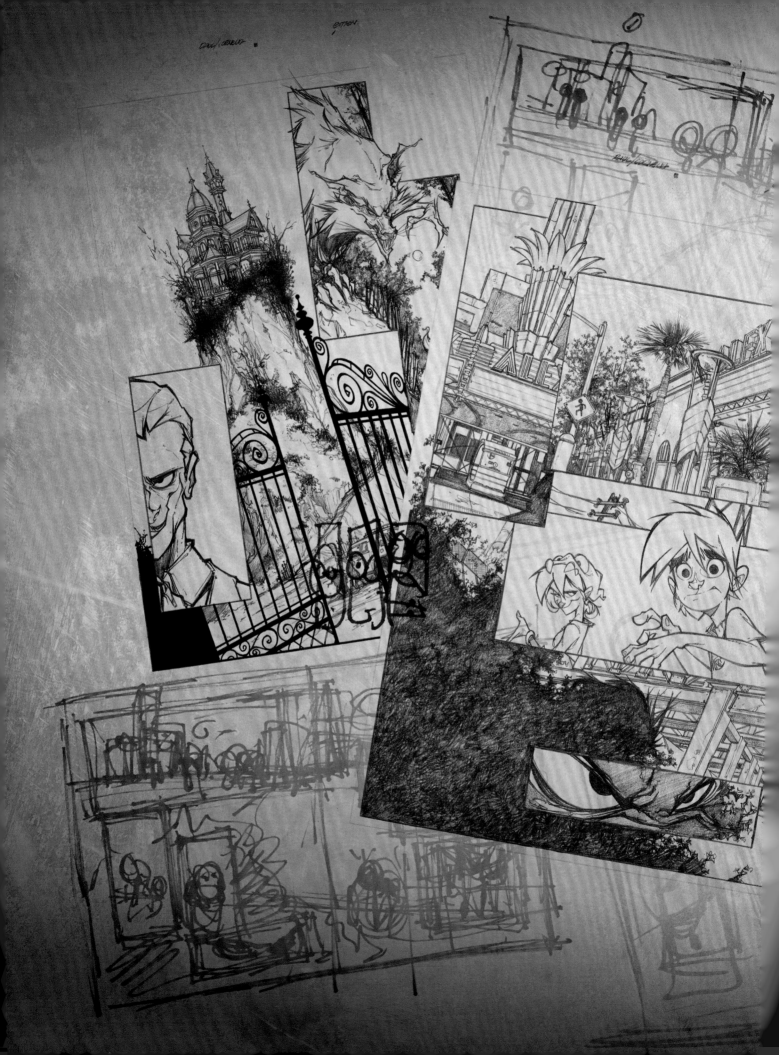

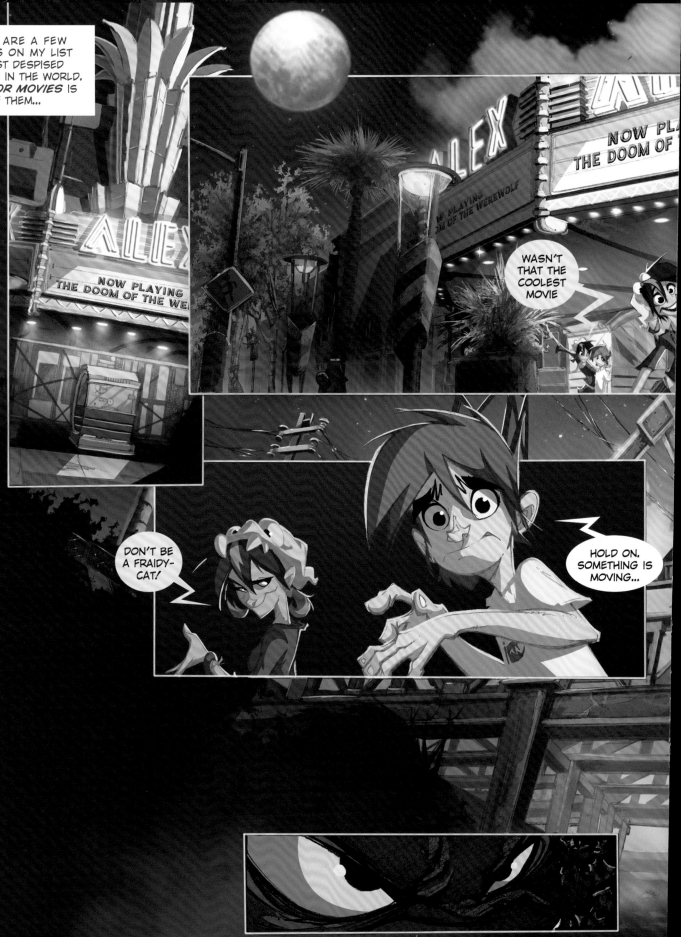
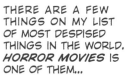

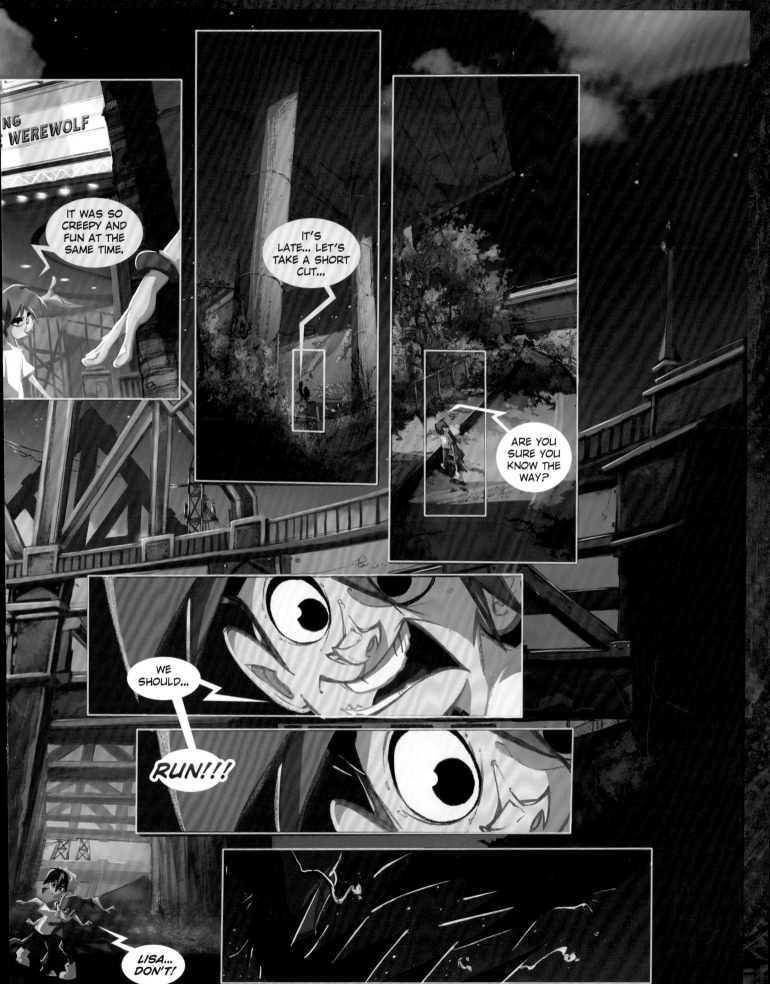

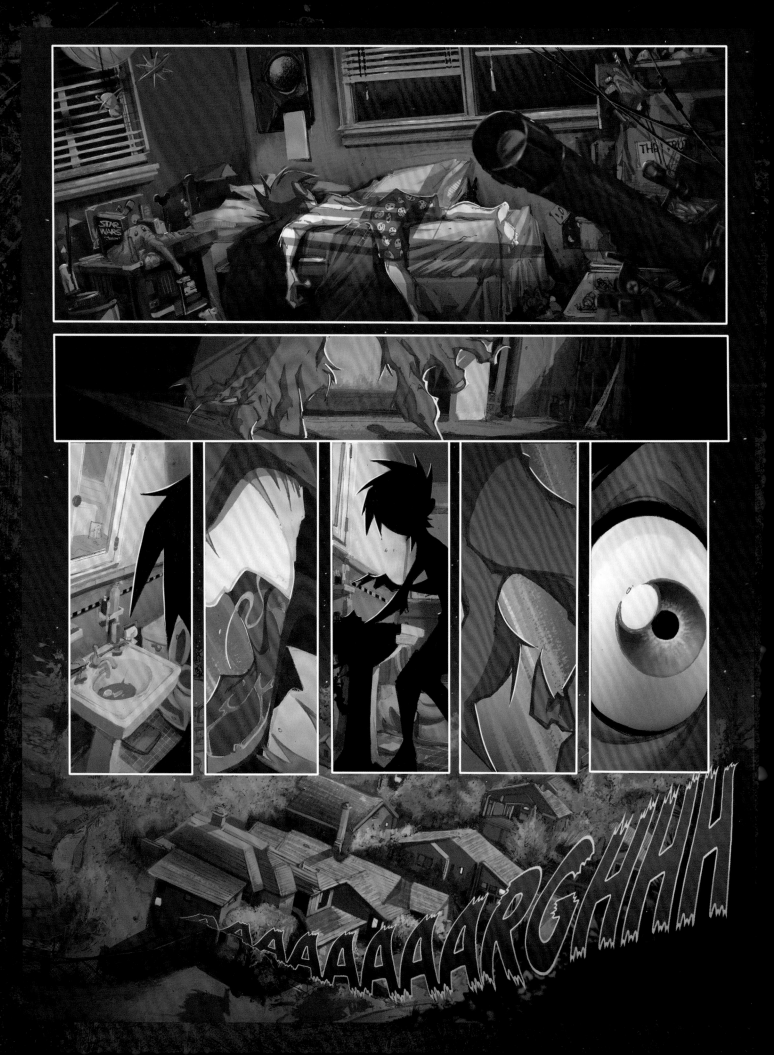

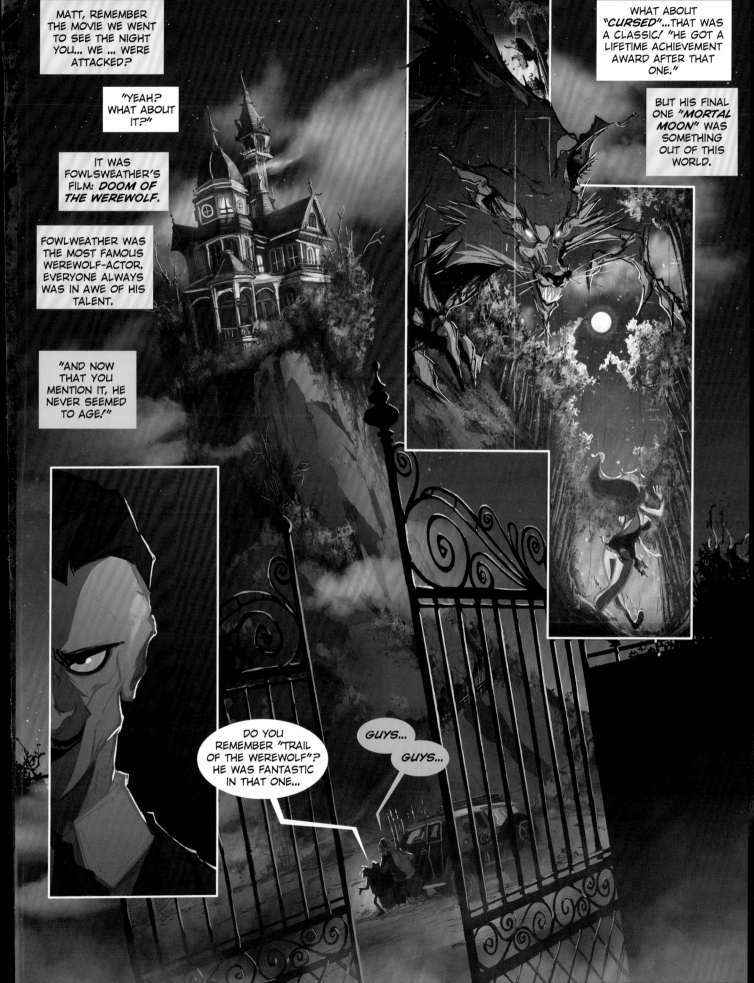

THANK
YOU!